Maine Coast Memories

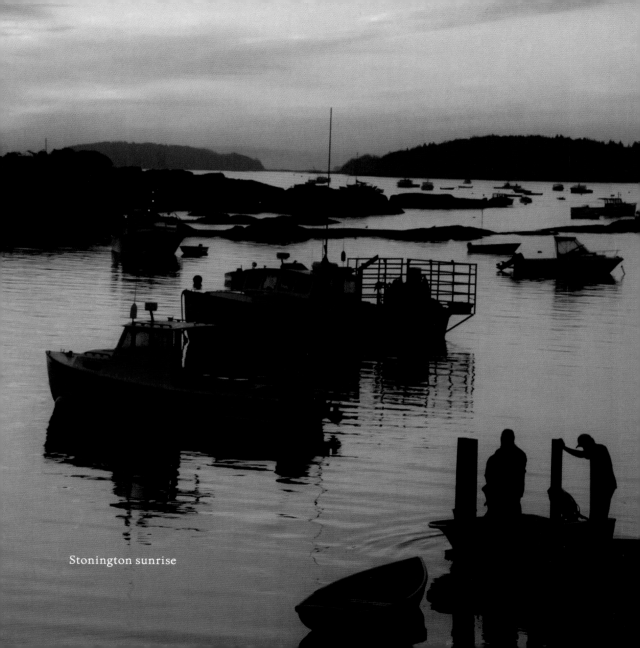

Stonington sunrise

Maine Coast Memories

David Middleton

With additional photography by
Brenda Berry

The Countryman Press
Woodstock, Vermont

Book design and composition by Susan McClellan

Published by The Countryman Press, P.O. Box 748, Woodstock, VT 05091
Distributed by W. W. Norton & Company, Inc., 500 Fifth Avenue, New York, NY 10110
Printed in China

10 9 8 7 6 5 4 3 2 1

Maine Coast Memories
978-0-88150-987-8

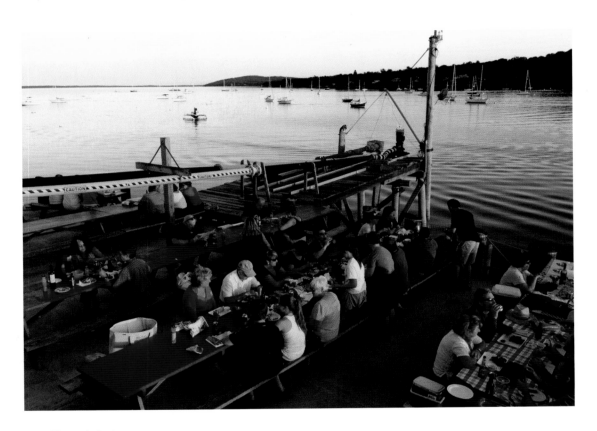

▲ Young's Lobster
Pound

Introduction

Vacation—What a wonderful word! Eating out, driving around, doing what you want when you want—why does anyone ever go home? Ok, there is that work thing, but life is too short to work all the time. Isn't it time to start planning your next trip, your next fun adventure? Where to this time?

How do your pictures turn out on vacation trips? Do you get some good shots? All nicely sorted and labeled and presented, are they? You must get up early and stay out all day with camera in hand, chasing the best light. Do you wait for those perfect moments, when the action is just right and everything looks perfect?

Well, of course not. You're on vacation! You have better things to do than wake up before dawn and wait around with your camera all day. You have fun all the time and you take pictures when you can. But don't worry! That's why there are professional photographers: somebody has to be out there taking pictures when everyone else is having a good time!

This book is for you, the fun people out there; consider it your personal photo album of the area. Hundreds of miles were driven, hours and hours were spent, and thousands of images were taken over many months to get the best of the best pictures for this book. We might not have taken *every* beautiful picture possible out there, but we believe we got most of them.

If, when looking through this book, you find that a favorite place was left out, I do apologize, but that just means it will stay hidden and private and "yours" a little while longer. If, on the other hand, you'd like to share your photos of favorite spots in this area, I have just the thing for you: Go to www.tcpmemorybooks.com and post your pictures of favorite places that should be included. Think of it as your own online second edition.

I'm thinking Washington, DC, or California's Wine Country or Vail, Colorado, would be good places to go next on vacation. Ready? See you there!

David Middleton, *series editor*

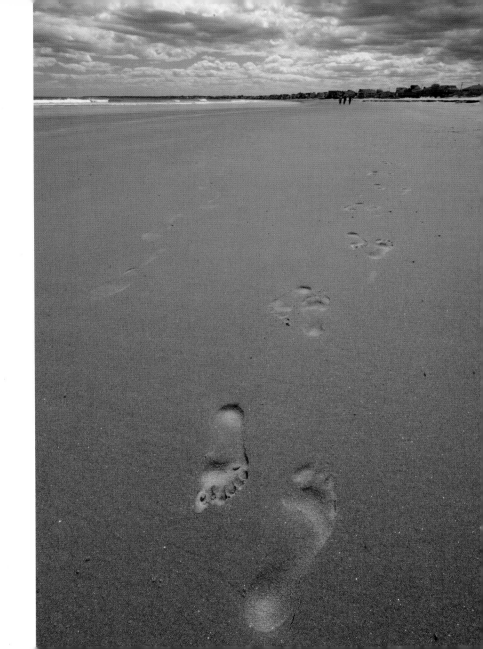

▶ Footprints,
Wells Beach

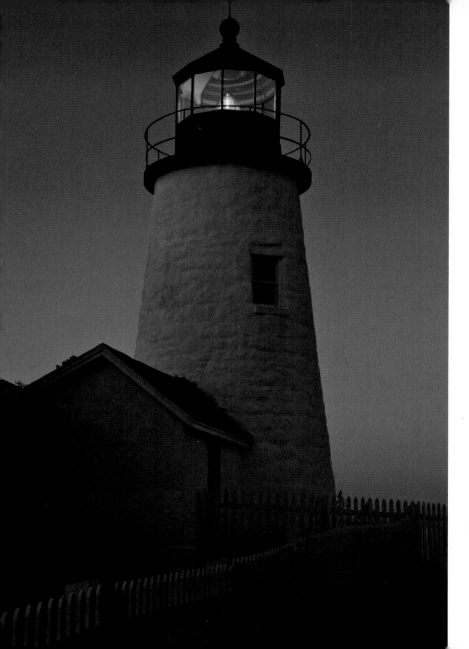

◀ Sunset, Pemaquid
Point Lighthouse

Maine Coast Memories

HERE IS A SIMPLE QUESTION: How many lighthouses are there on the coast of Maine? Nothing tricky here, just a straightforward calculation. Yet apparently nobody really knows. Web searches say 73, or rather 61, no wait, 66. Definitive books give definitively different answers. There seems to be something about the lighthouses on the coast of Maine that is simply beyond the human ability to count.

Now, it could be that the lighthouses of Maine come and go, so at any one moment no one really knows how many there are. Anybody who has spent time on the coast on a pea-soup foggy day ("Should've been there by now!") can verify the here-yesterday, gone-today, who-knows-tomorrow nature of the area.

It is not inconceivable that, on the 3,478 miles of coastline in Maine, a lighthouse or twelve could go missing for a month or a year or two. Not impressed with the Maine coastline? Little ol' Maine has more miles of coastline than big ol' California, and more lighthouses too . . . I think.

It also could be that, with 2,000 islands along the coast, there are lighthouses where no one thought there would be. Many of these beautiful islands are uninhabited, protected by rocky ledges and granite cliffs and covered in dense spruce forest, so a lighthouse could easily go unnoticed.

Or it simply might be that, with 70 million pounds of lobsters and 40 million pounds of blueberries harvested each year, with 30 miles of beaches and more ice cream stands, lobster shacks, and microbreweries than you can shake an oar at, everyone is having such a good time that nobody really cares how many lighthouses are on the coast of Maine.

I, for one, would like to know, but every time I start to count I get distracted by a beautiful harbor, the wind in a sail, a smiling face, crashing waves on a rocky point, or a drippingly delicious ice cream cone. Maybe that's the answer. With so much to do and see on the coast, counting lighthouses slips down the gotta-do list.

I guess I'll have to go back and doggedly suffer through the many pleasures of the Maine coast in search of its elusive lighthouses—again and again and again, if I'm lucky!

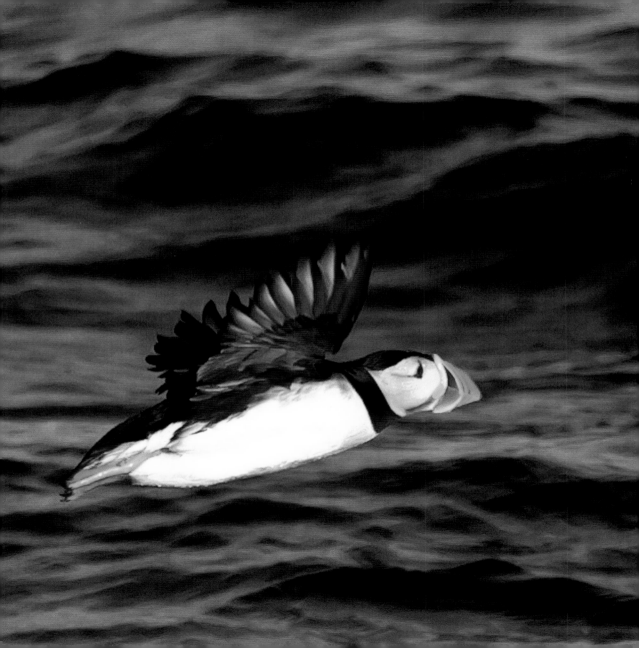

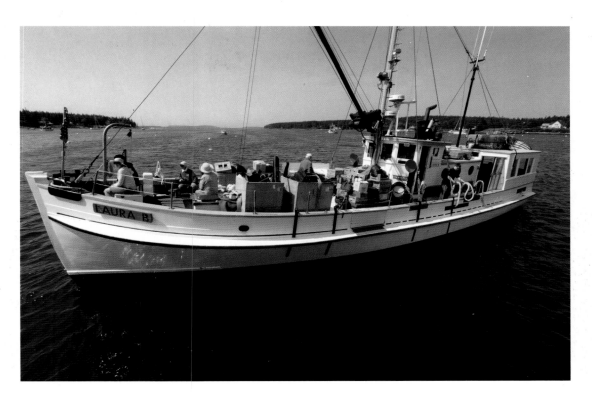

▲ The *Laura B.,* Port Clyde

◀ Atlantic puffin

▲ South Bristol

▲ Lobstering gear

MAINE COAST MEMORIES

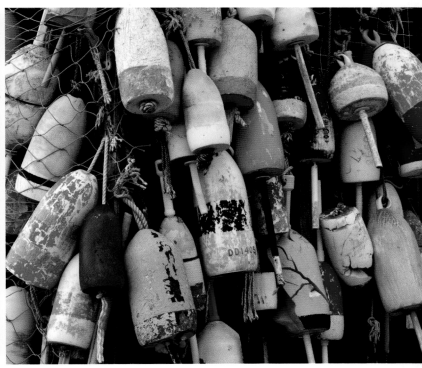

▲ Lobster buoys on shed

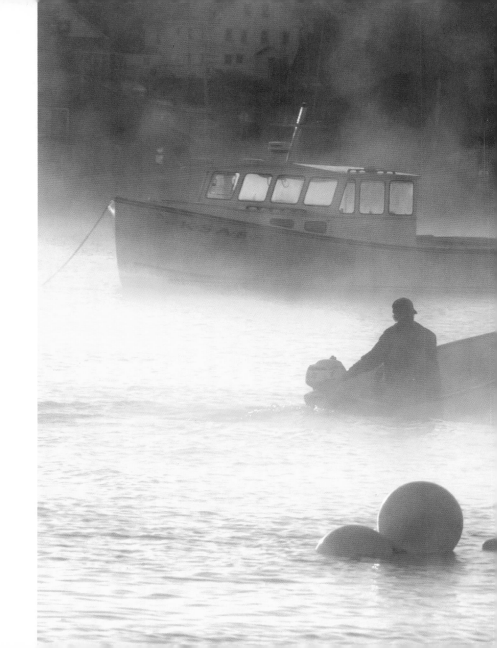

▶ Heading
for work,
Bass
Harbor

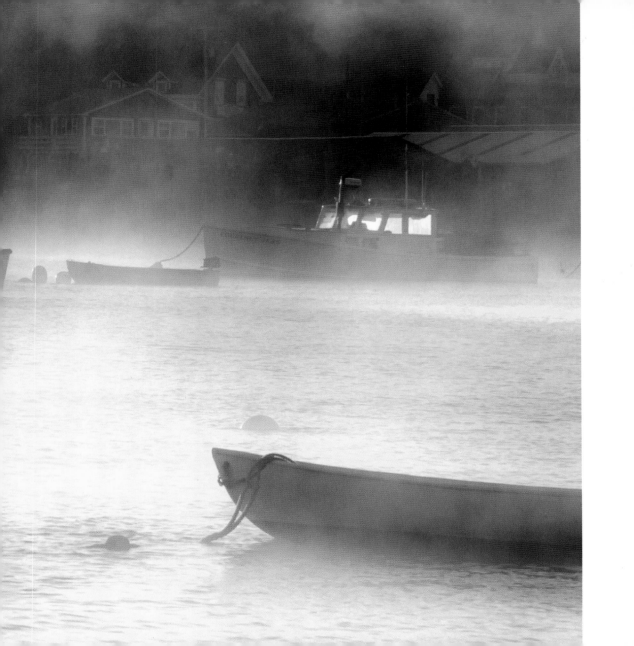

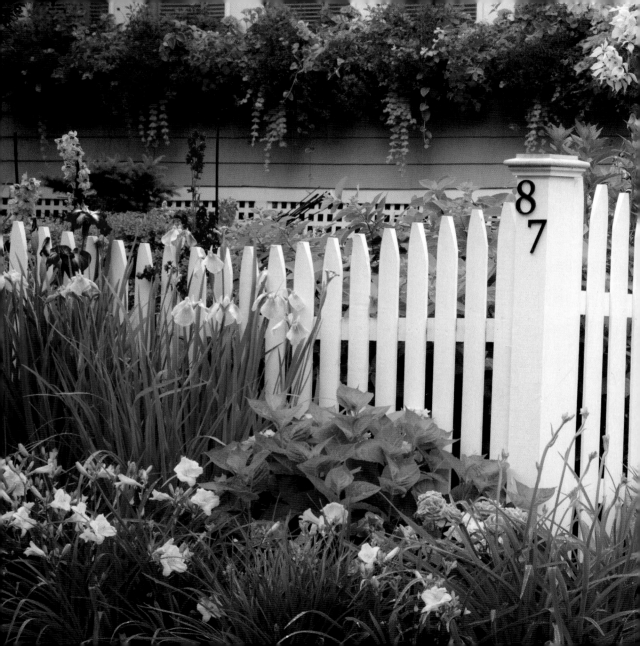

◀ A lovely garden

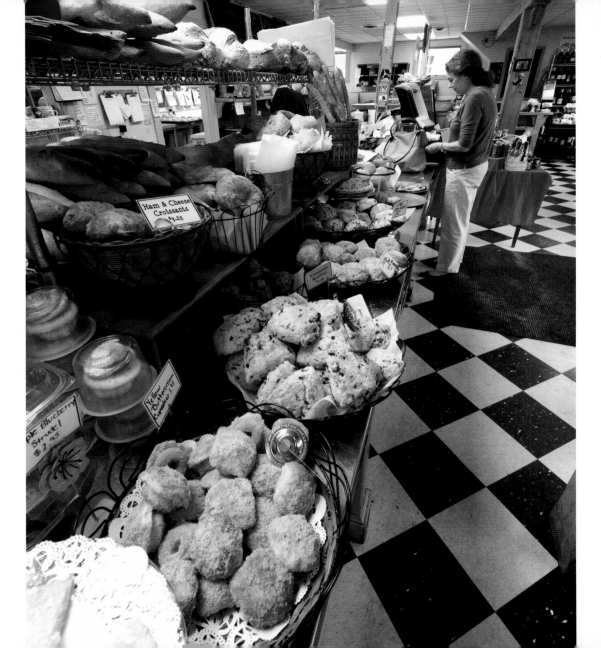

▲ Main Street, Ogunquit

◀ The Market Basket, Rockport

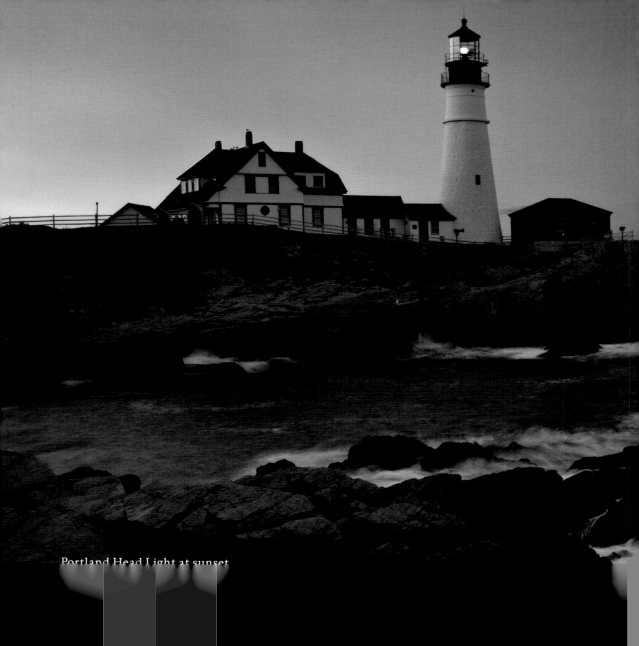

Portland Head Light at sunset

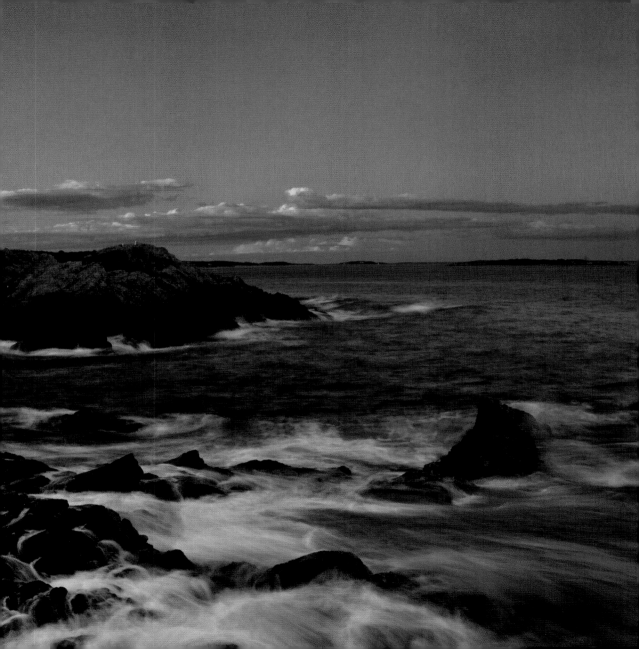

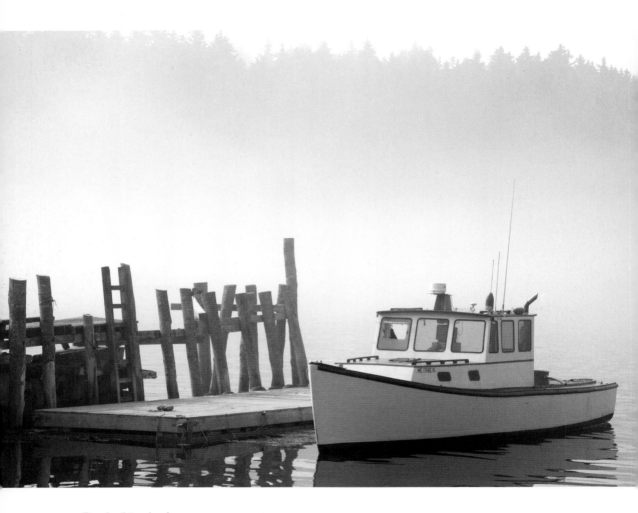

▲ Docked in the fog
at Spruce Head

MAINE COAST MEMORIES

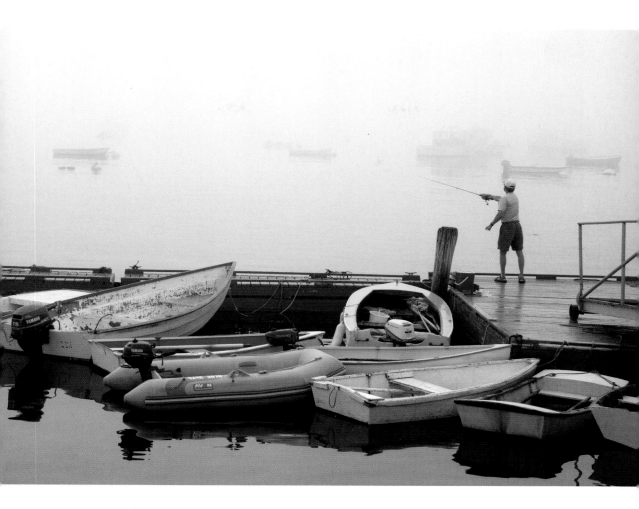

▲ Fisherman,
Owls Head Harbor

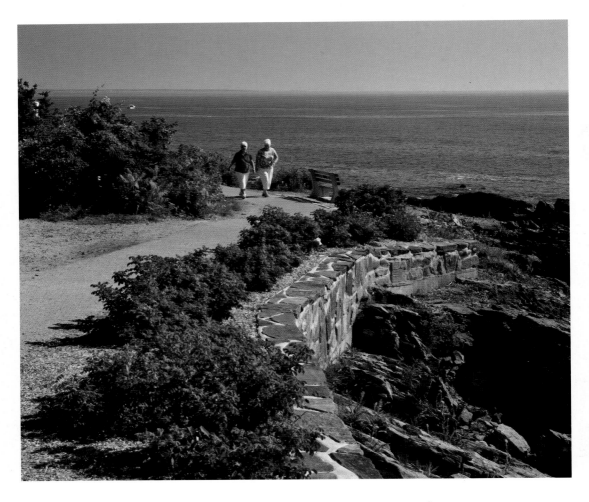

▲ Marginal Way,
 Ogunquit

▶ Carriage Path,
 Acadia National Park

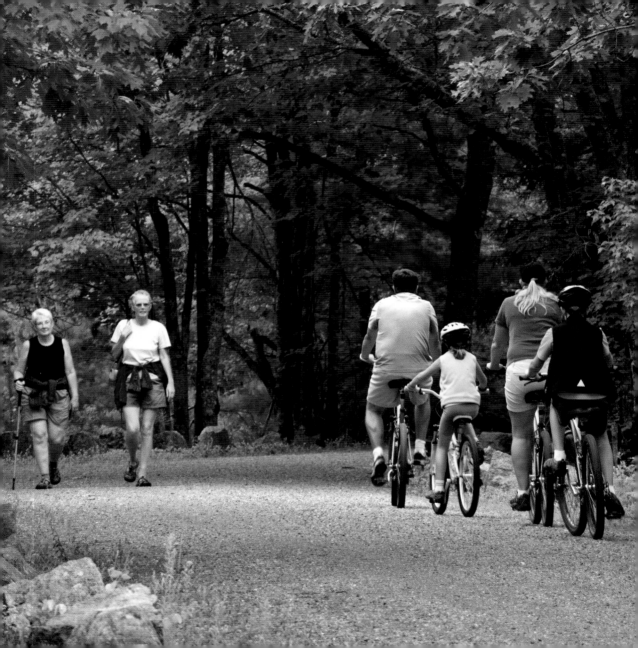

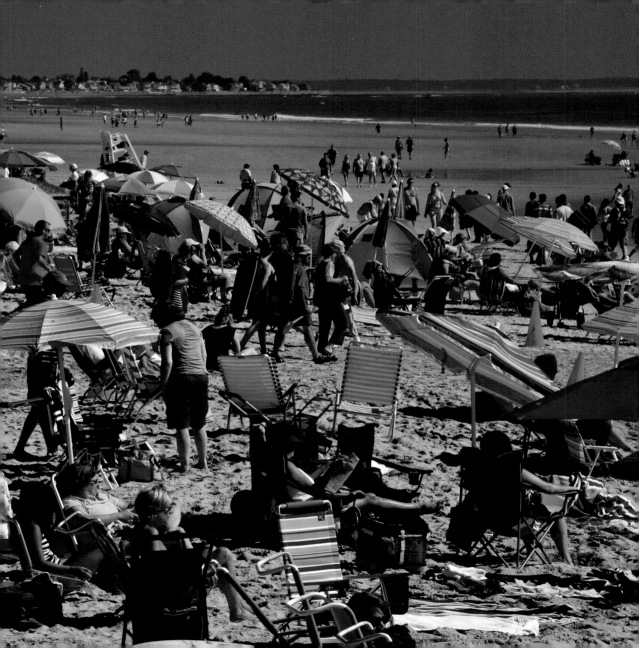

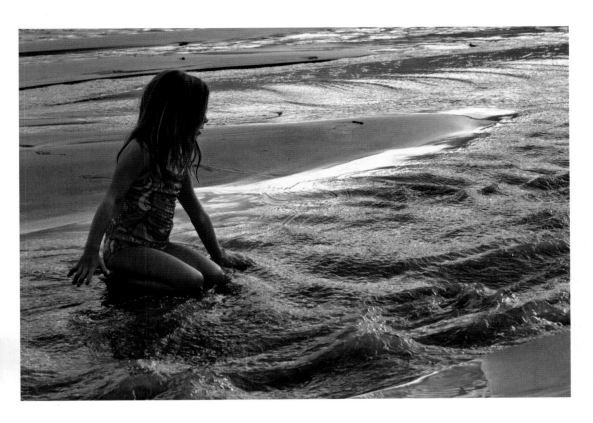

◀ Ogunquit Beach

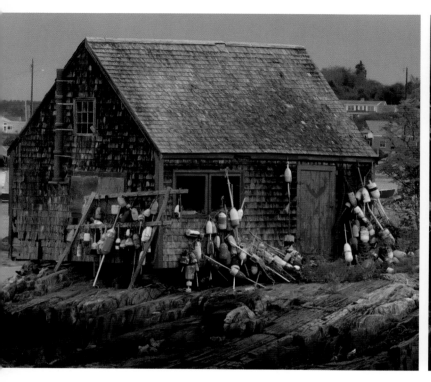

▲ Lobsterman's shack,
Mackerel Cove

▲ Lobsters just off
the boat

MAINE COAST MEMORIES

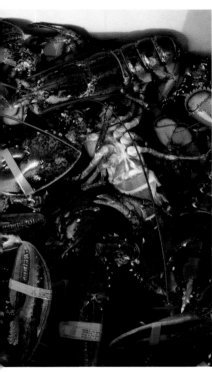

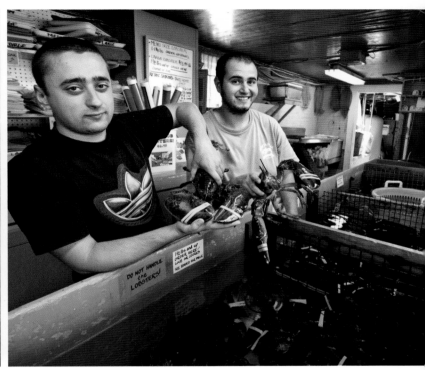

▲ Lobster for sale,
New Harbor

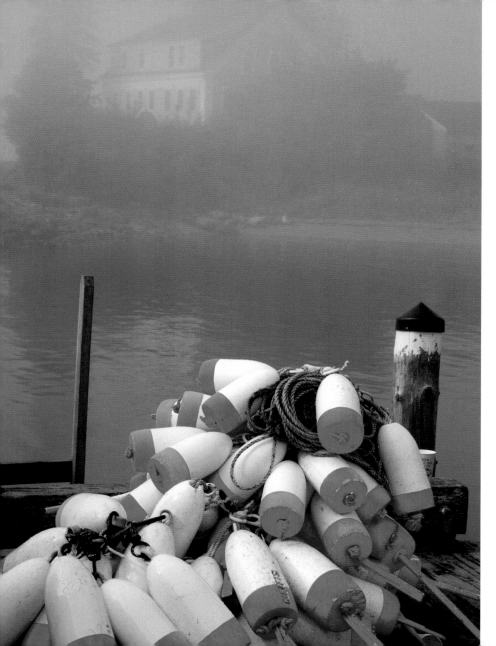

◀ Buoys, Owls
Head Harbor

▶ At Palace Pete's,
Old Orchard
Beach

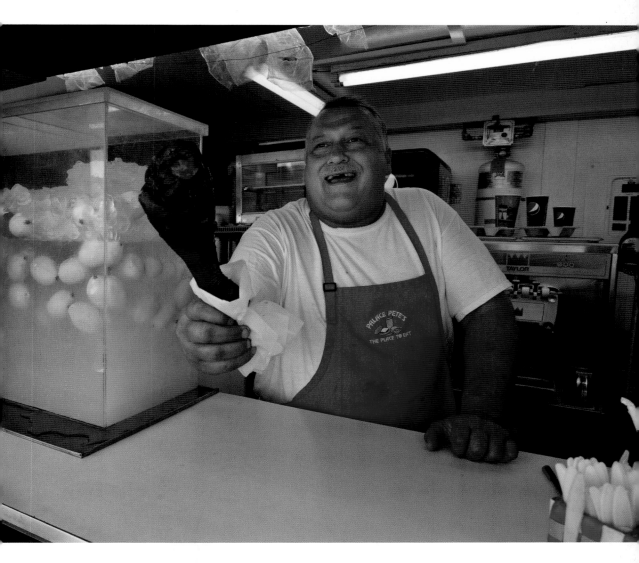

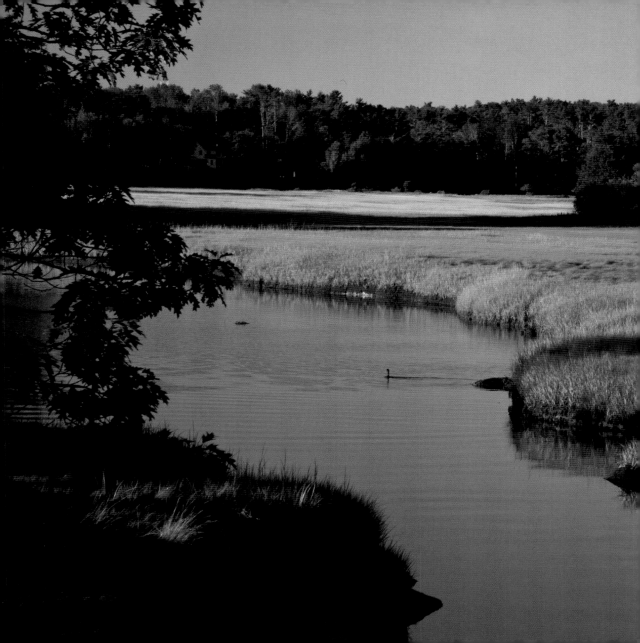

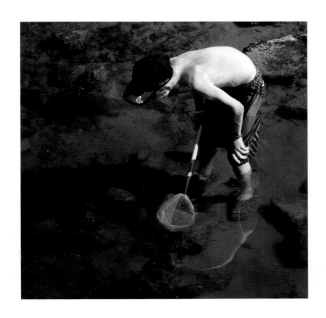

▲ Searching for bait

◀ Salt marsh, York

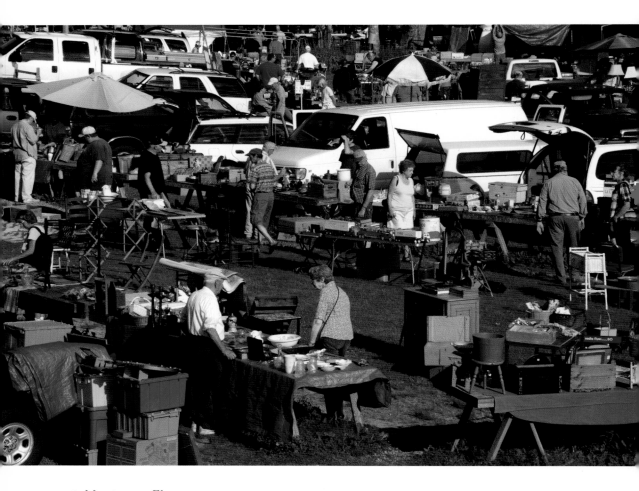

▲ Montsweag Flea
Market

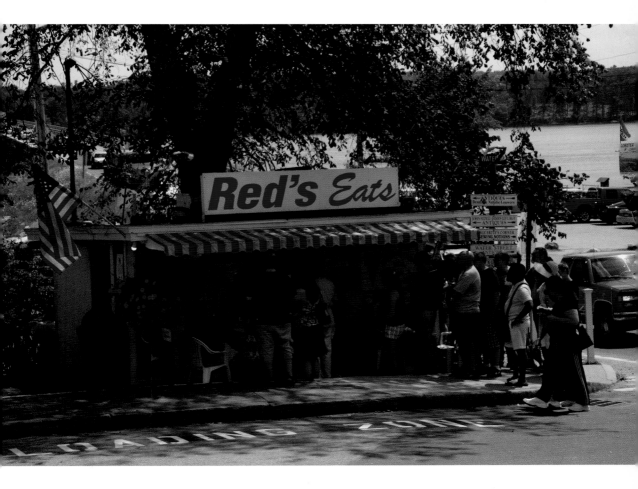

▲ Red's Eats, Wiscasset

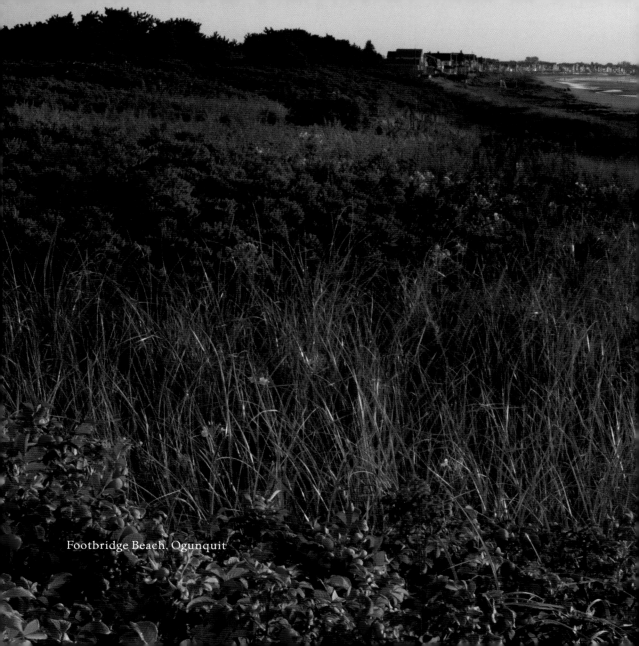

Footbridge Beach, Ogunquit

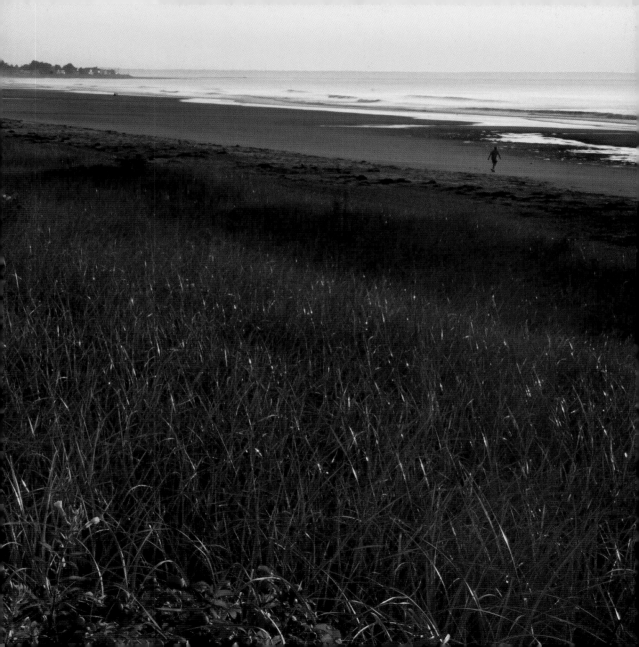

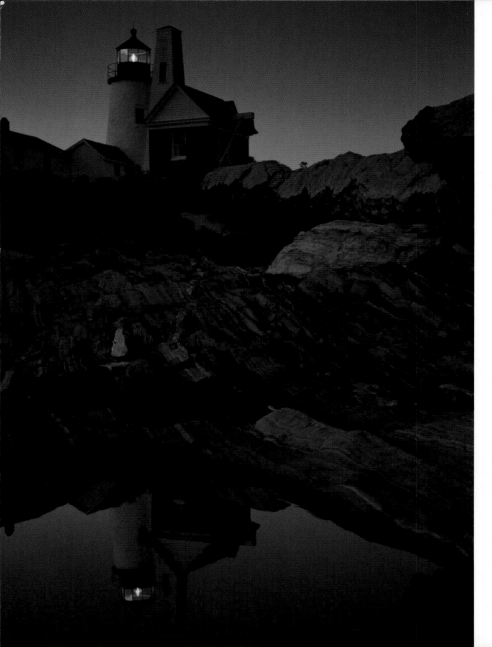

◀ Pemaquid
Lighthouse
at sunset

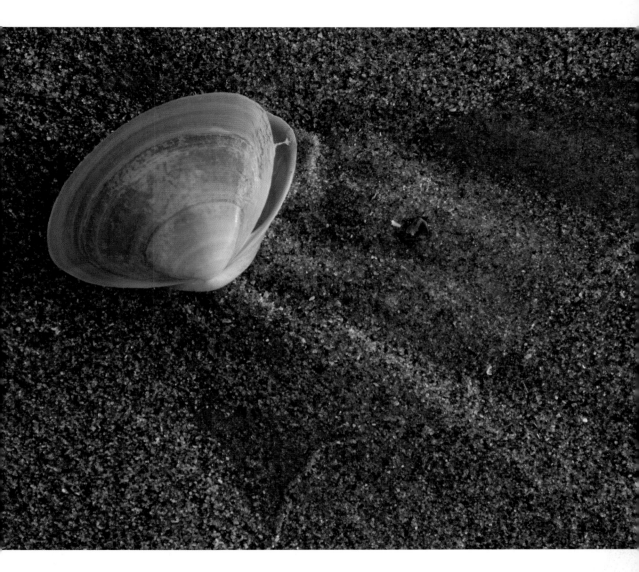

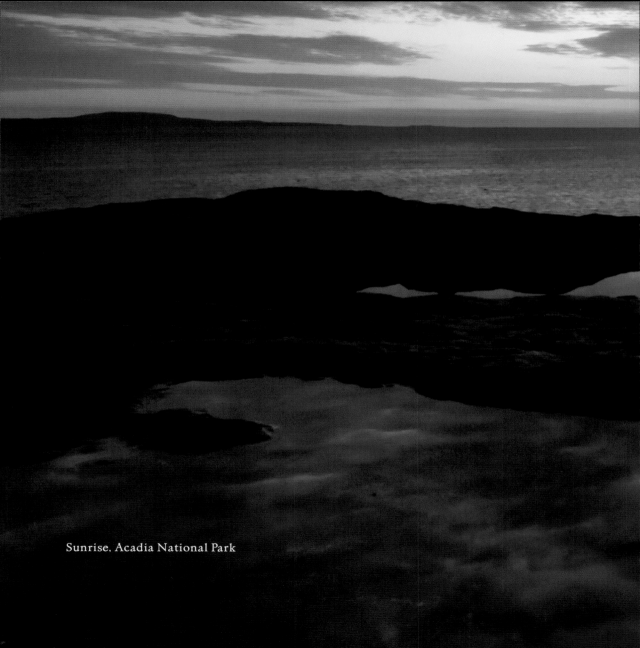

Sunrise, Acadia National Park

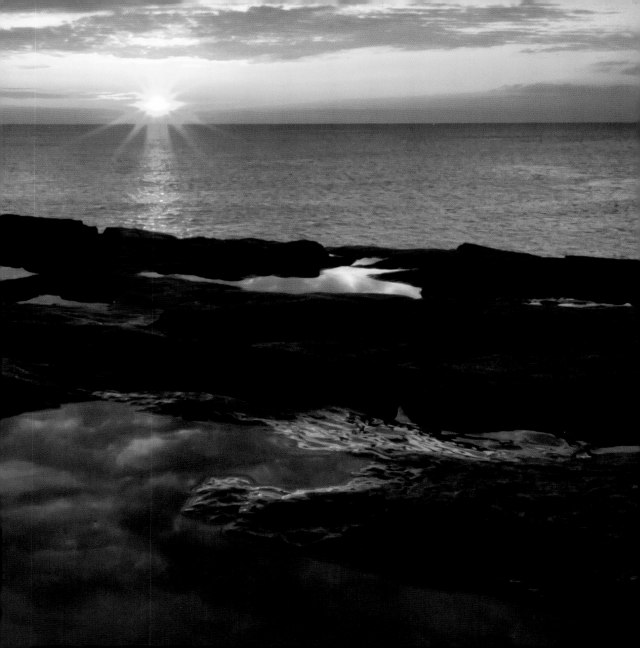

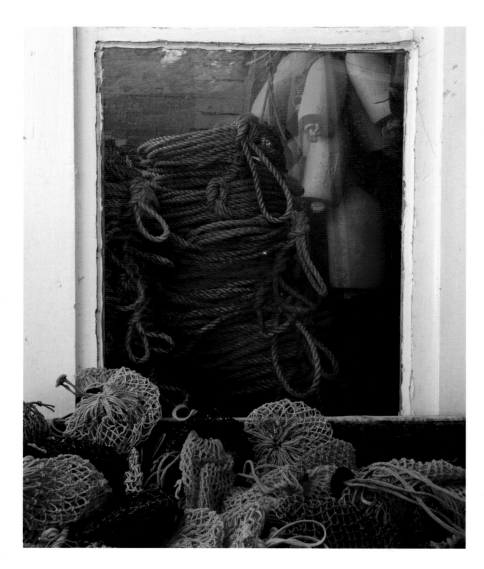

◀ Window
detail,
Stonington

▶ Monhegan
souvenirs

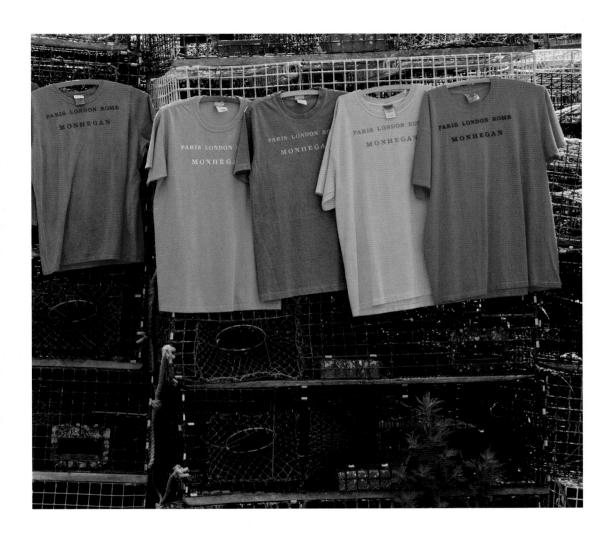

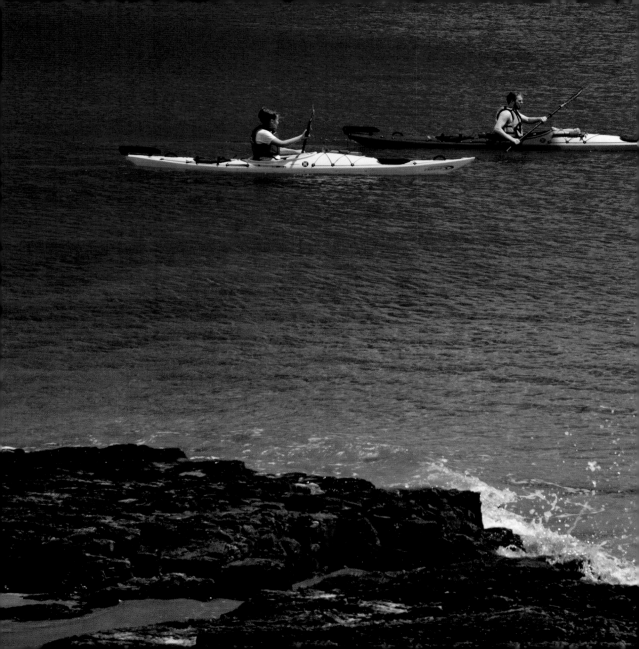

◀ Kayakers,
Kennebunkport

45

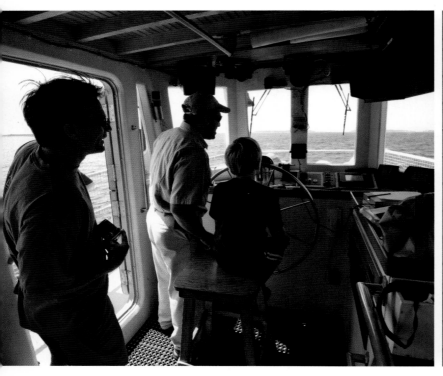

▲ Captains of the ferry
 Laura B.

▲ Seen in Portland

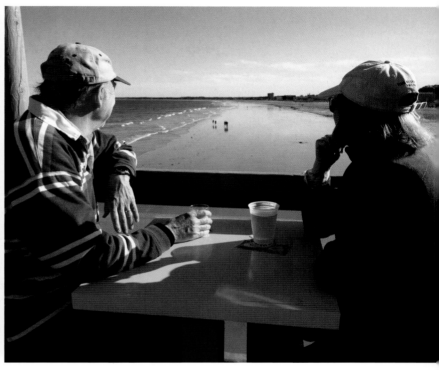

▲ View from the pier,
Old Orchard Beach

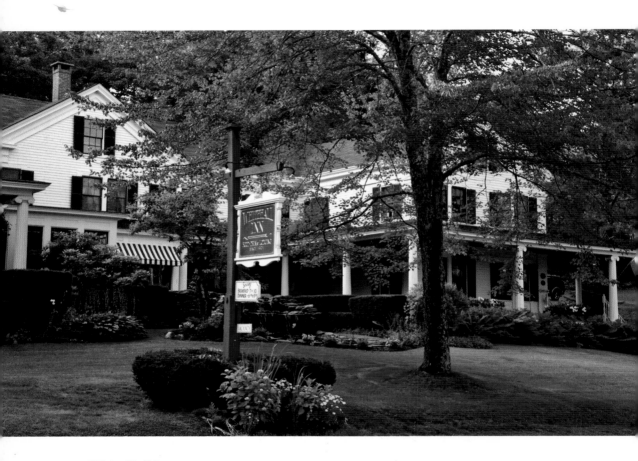

▲ White Hall Inn,
Camden

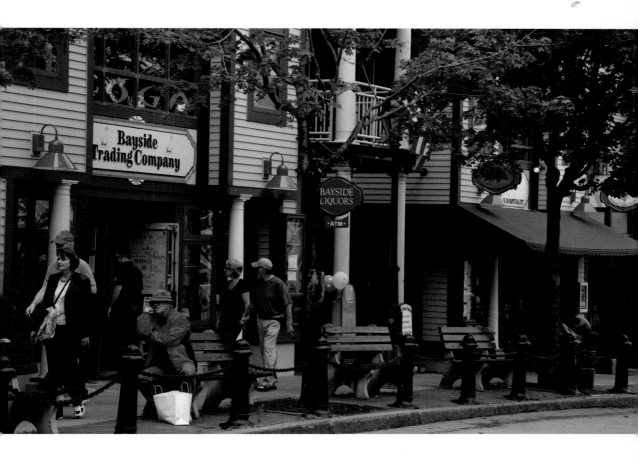

▲ Main Street, Bar Harbor

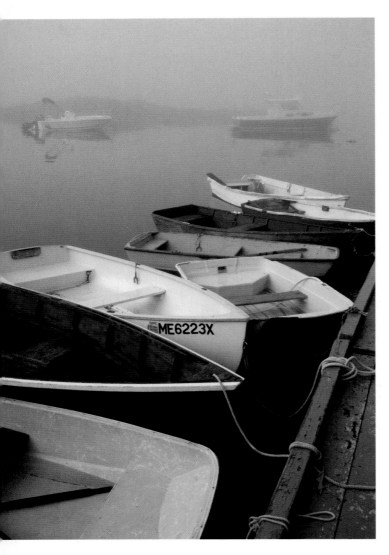

◀ Skiffs, Southport

▶ Corea Harbor

▶ ▶ A dory on the
dock at New Harbor

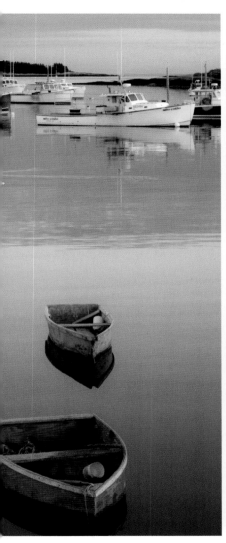

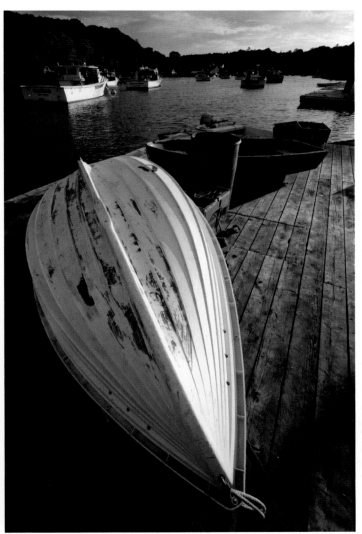

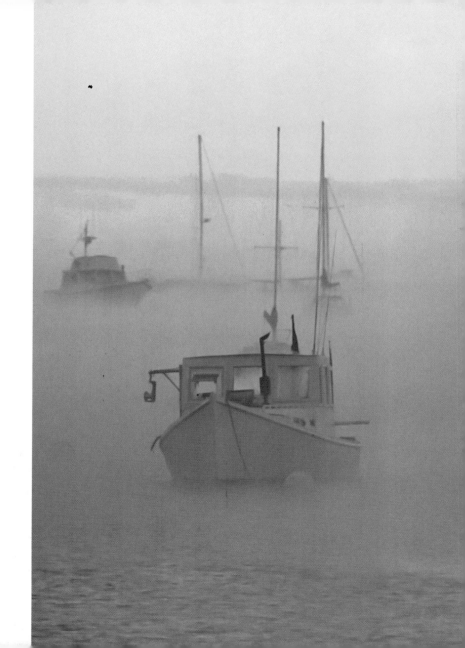

▶ Fog, Rockport
Harbor

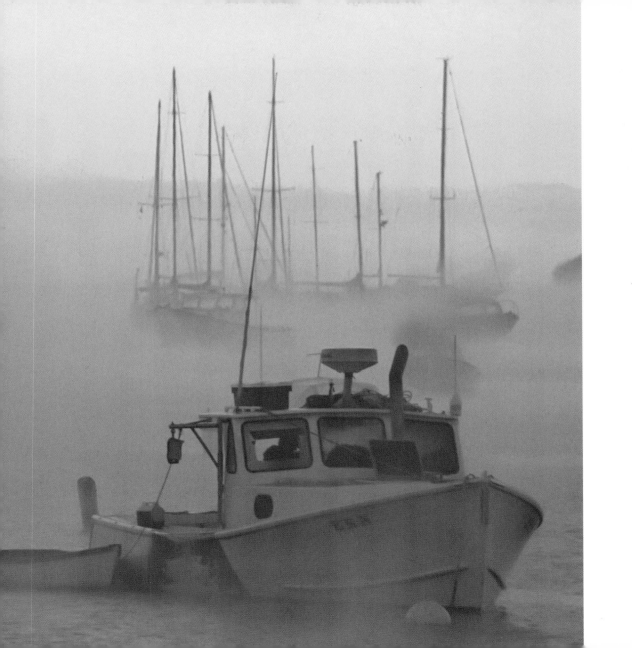

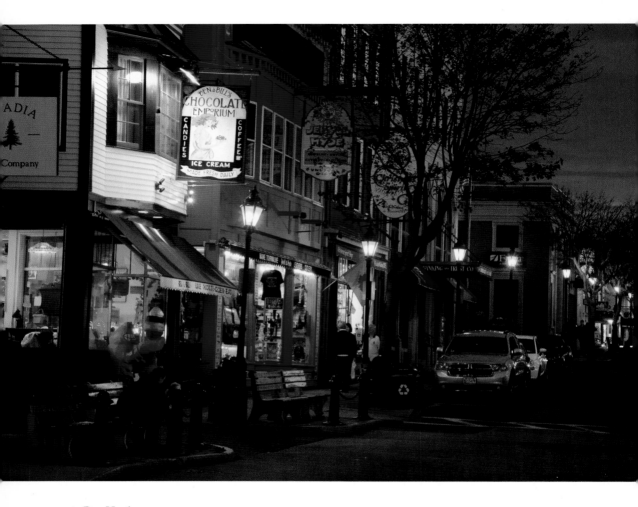

▲ Bar Harbor

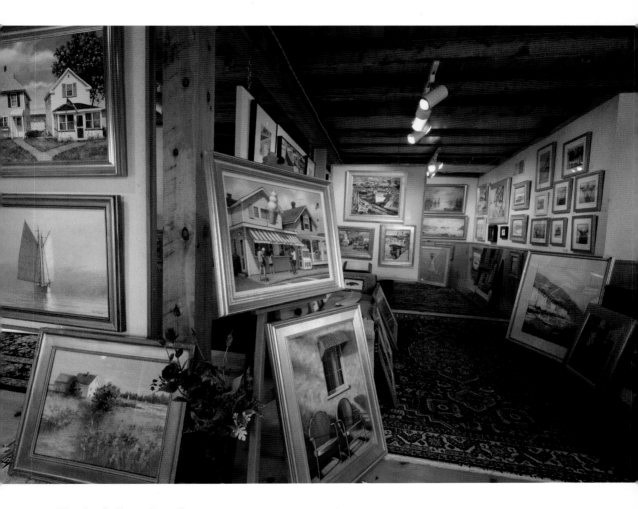

▲ Wright Gallery, Cape Porpoise

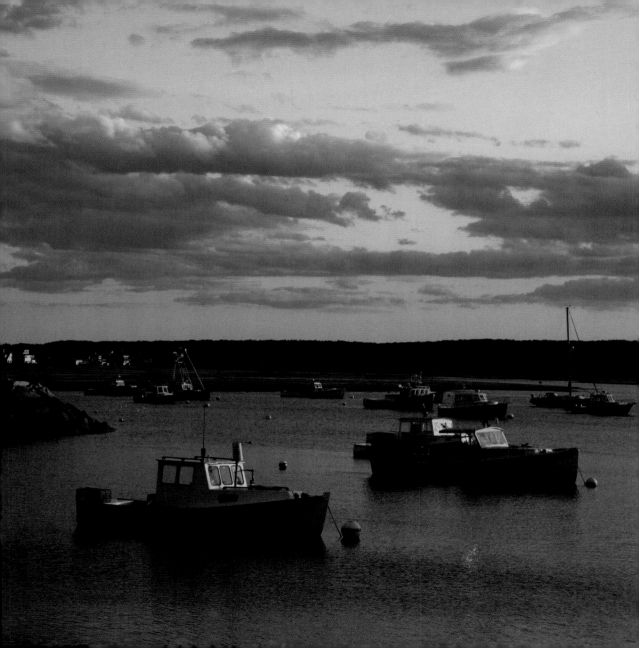

▲ The Island Inn,
 Monhegan Island

◀ Biddeford Pool at sunset

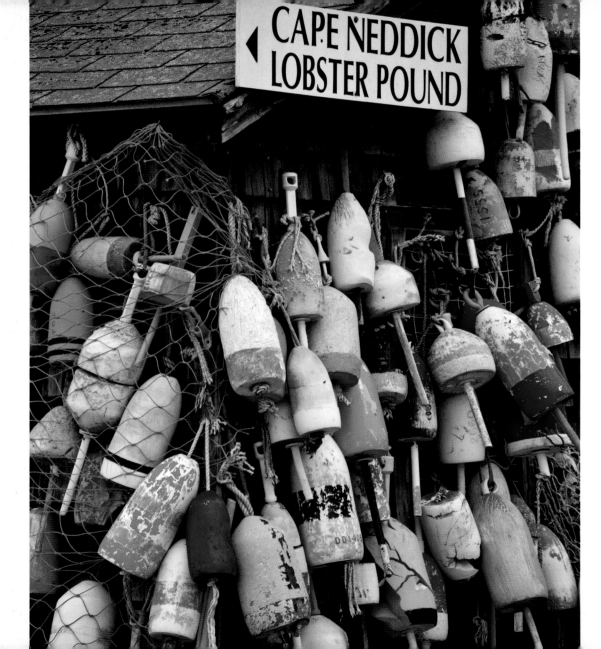

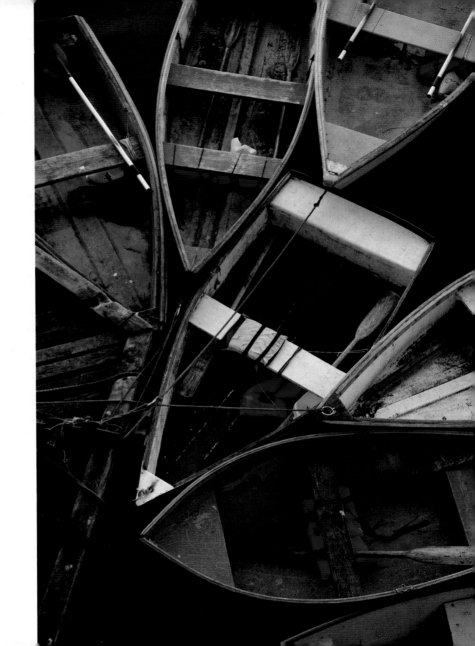

▶ Dories

◀ Cape Neddick
 lobster shack

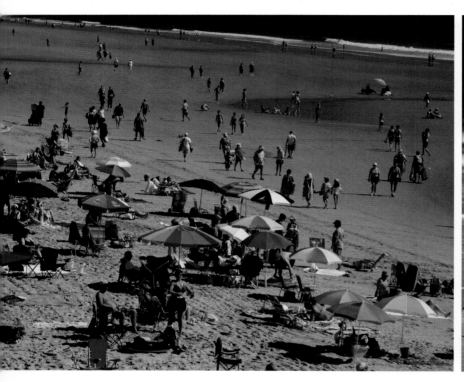

▲ Ogunquit Beach

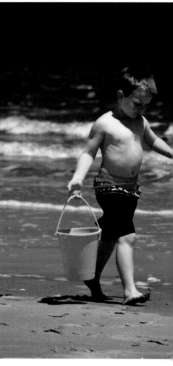

▲ On Popham Beach

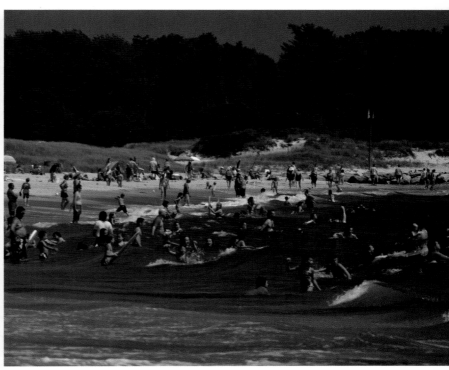

▲ Summer waves,
Point Beach

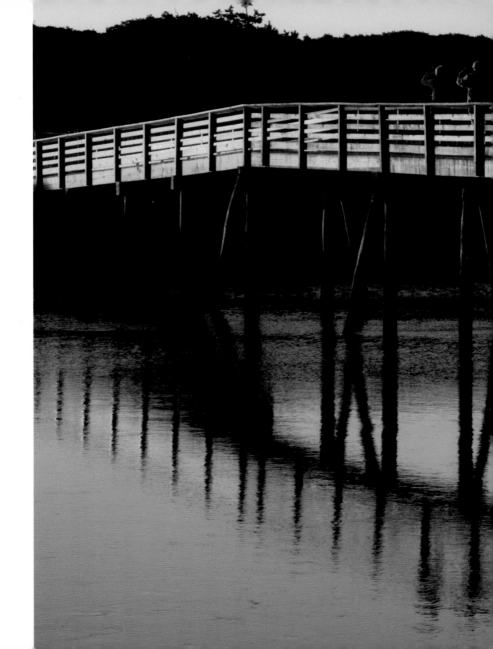

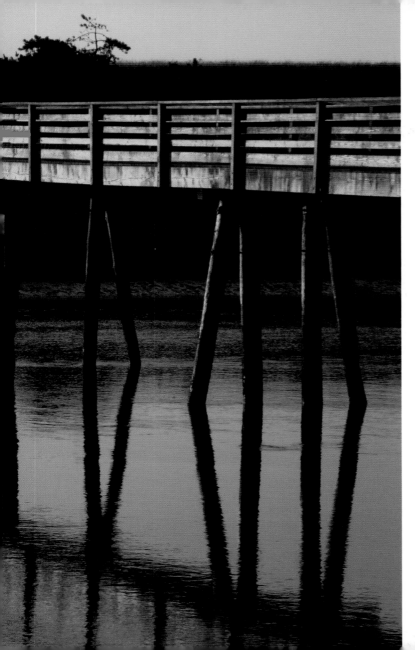

◀ The footbridge at
Footbridge Beach,
Ogunquit

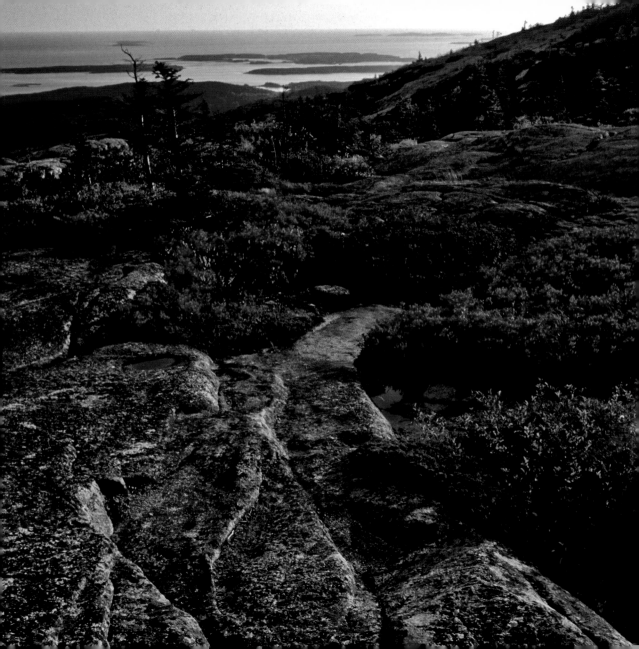

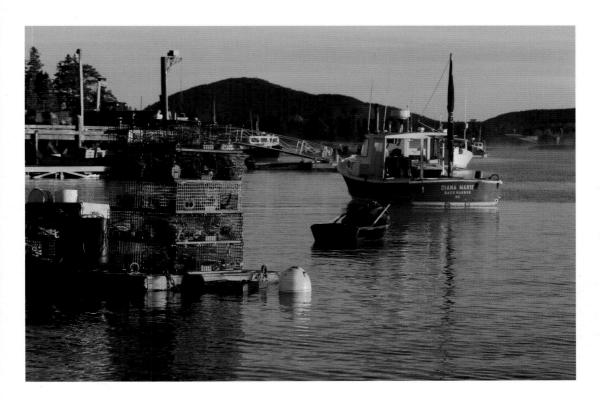

▲ Bass Harbor

◀ Top of Cadillac Mountain,
Acadia National Park

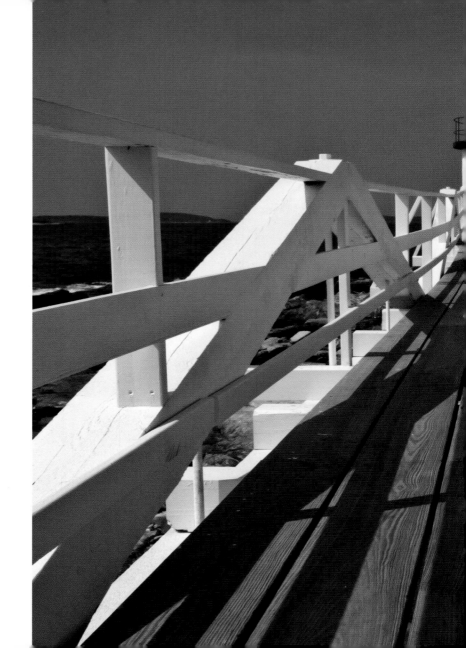

▶ Marshall Point
Lighthouse

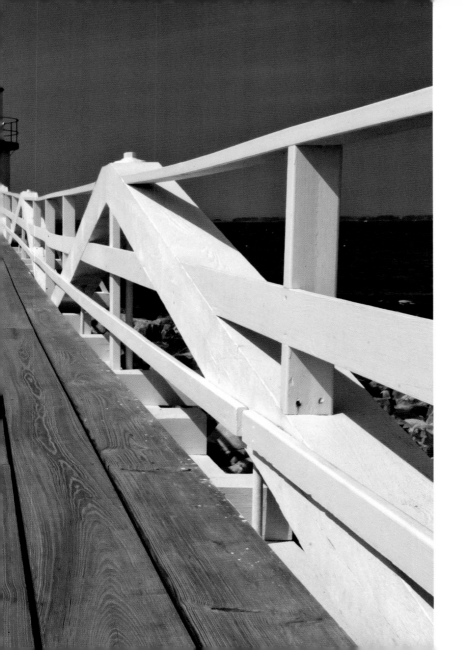

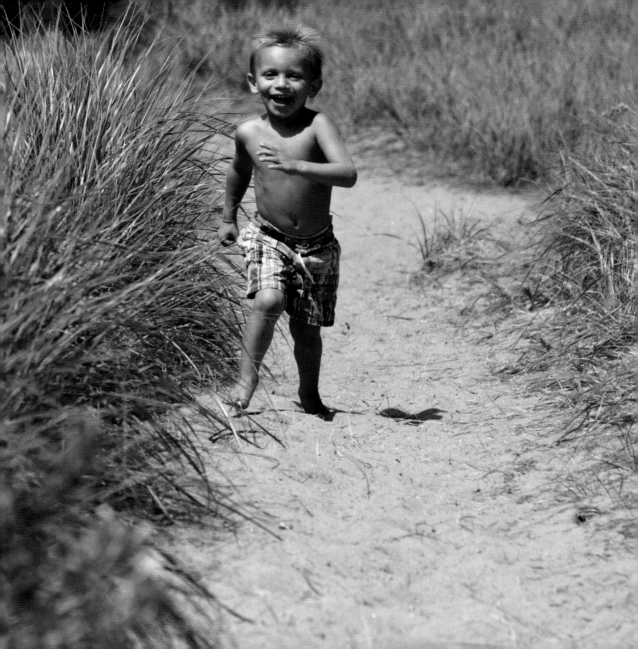

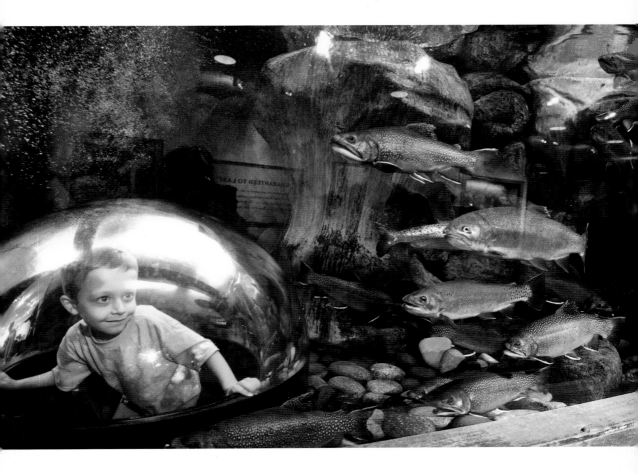

▲ Having fun in the trout
 tank at L.L. Bean, Freeport

◀ Running in the dunes

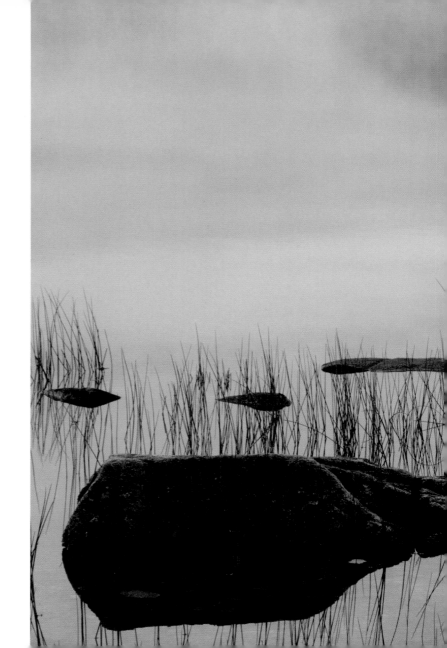

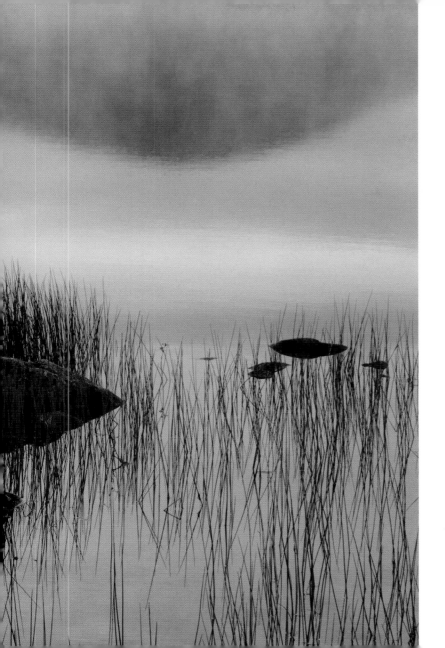

◀ Eagle Lake in Acadia
National Park

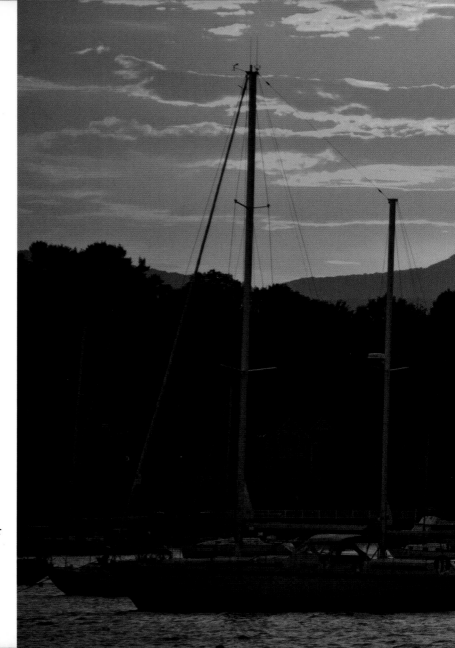

▶ Rockport Harbor

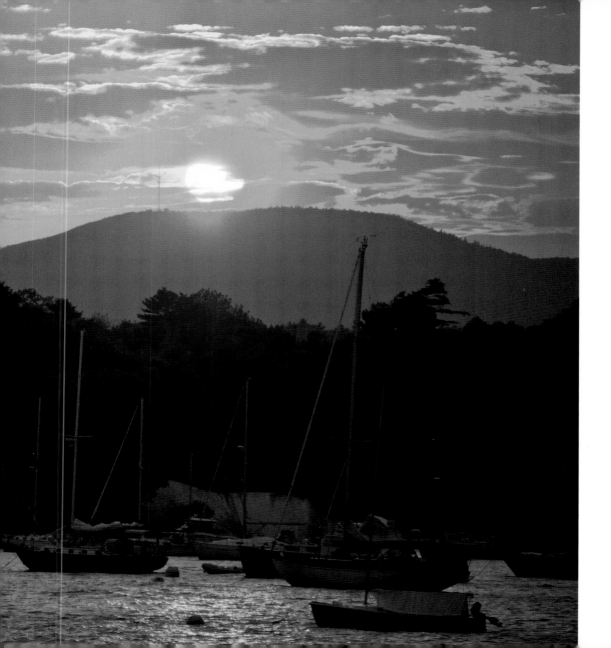

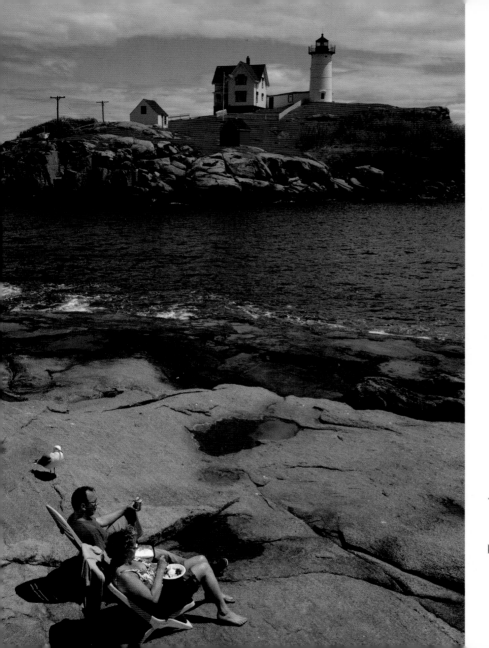

◀ Nubble Light,
Cape Neddick

▶ Ogunquit Beach

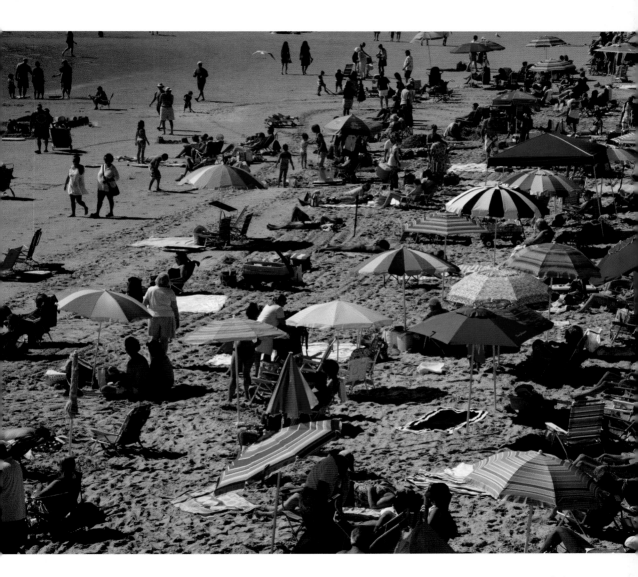

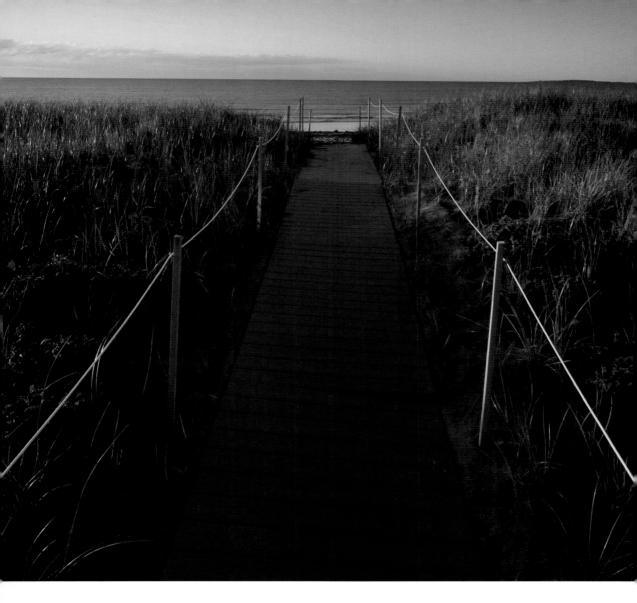

MAINE COAST MEMORIES

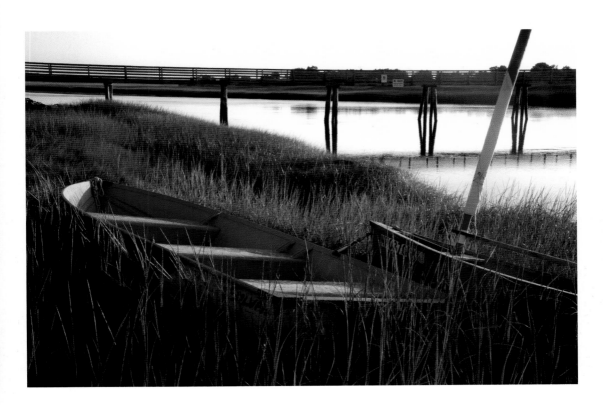

▲ Footbridge and skiffs,
 Footbridge Beach

◀ Old Orchard Beach boardwalk

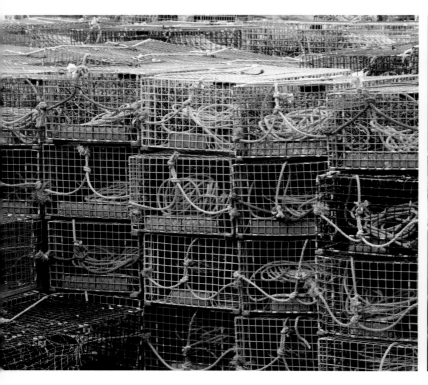

▲ Lobster pots

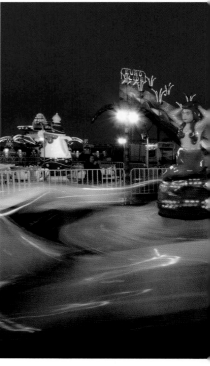

▲ Palace Playland,
Old Orchard Beach

MAINE COAST MEMORIES

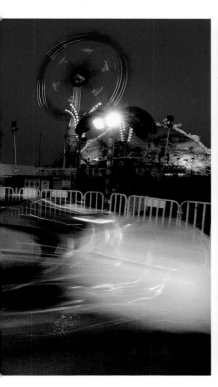

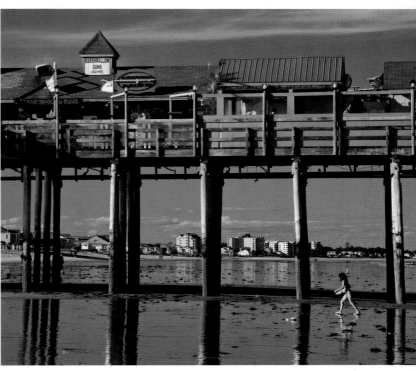

▲ Old Orchard Beach pier

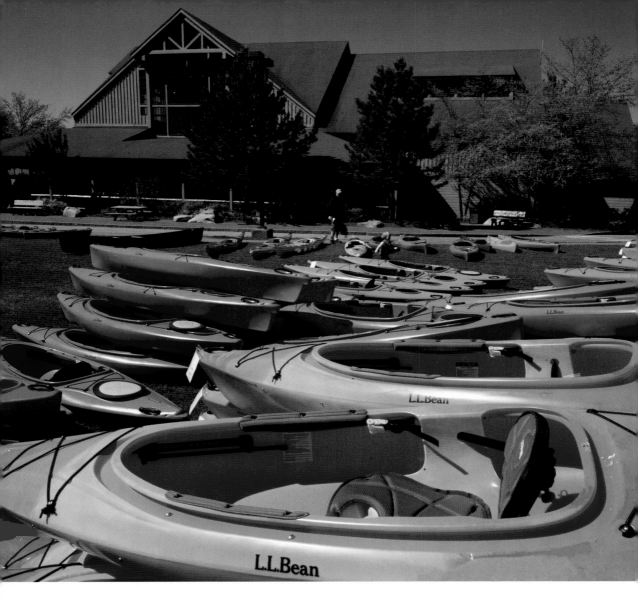

MAINE COAST MEMORIES

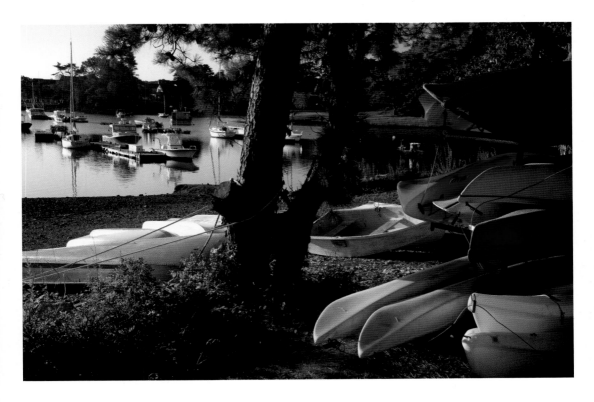

▲ York Harbor with kayaks

◀ Outside L.L. Bean, Freeport

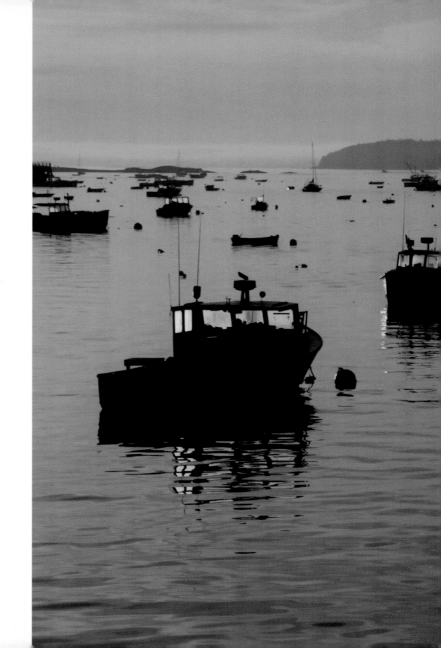

▶ Stonington Harbor

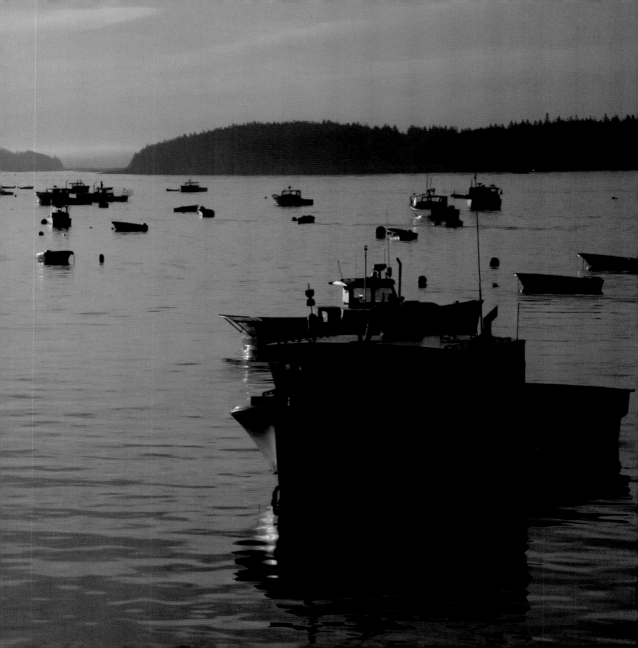

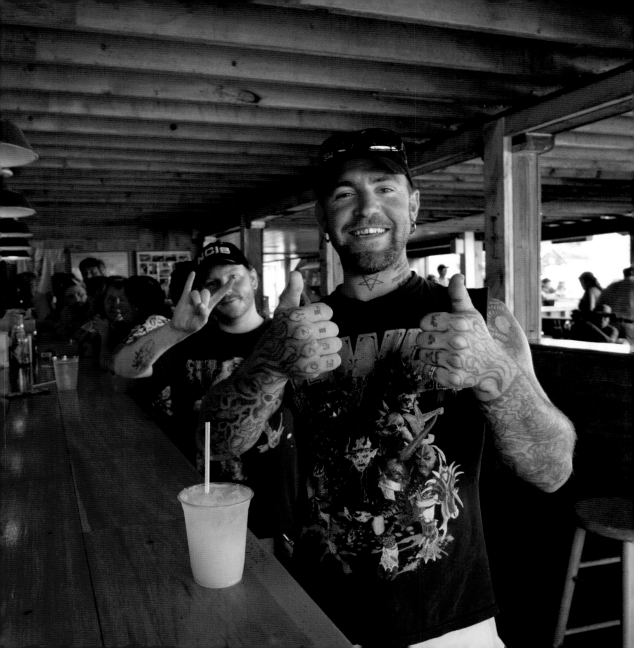

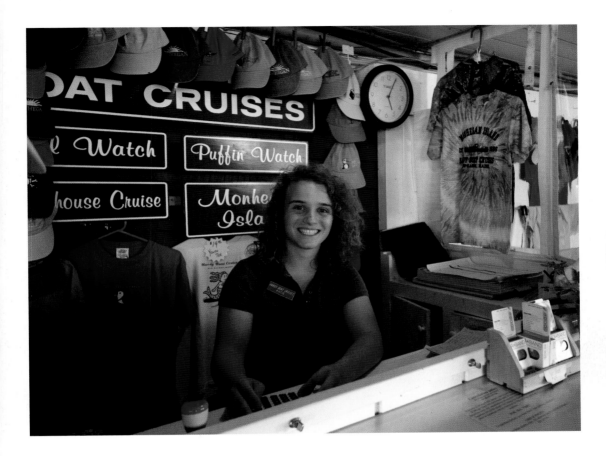

▲ The Hardy Boat Cruise
 booth, New Harbor

◀ Shaw's Bar, New Harbor

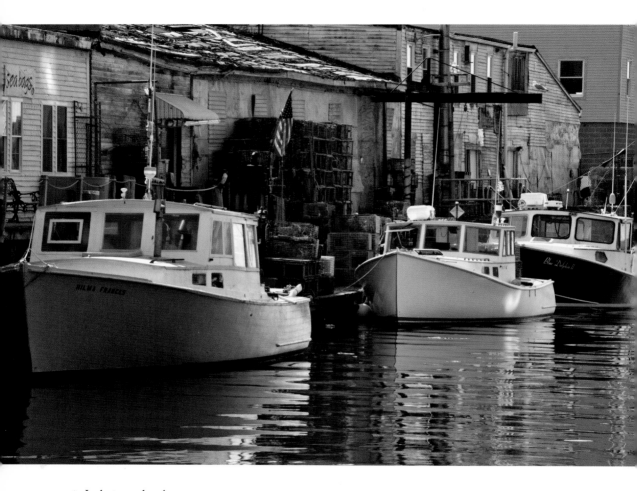

▲ Lobster wharf,
Portland

MAINE COAST MEMORIES

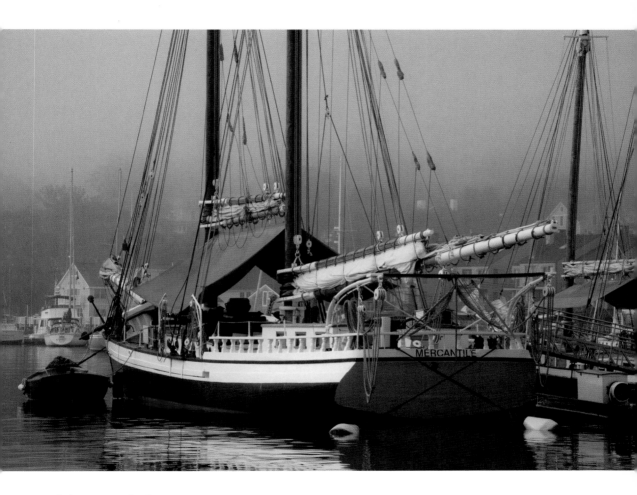

▲ Schooner at dock,
Camden

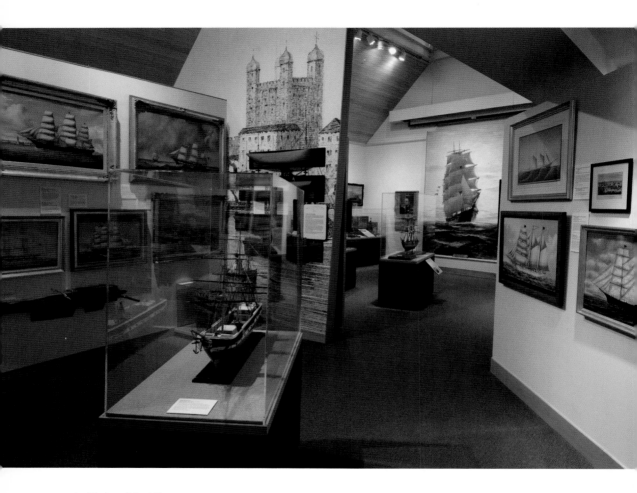

▲ Maine Maritime
 Museum, Bath

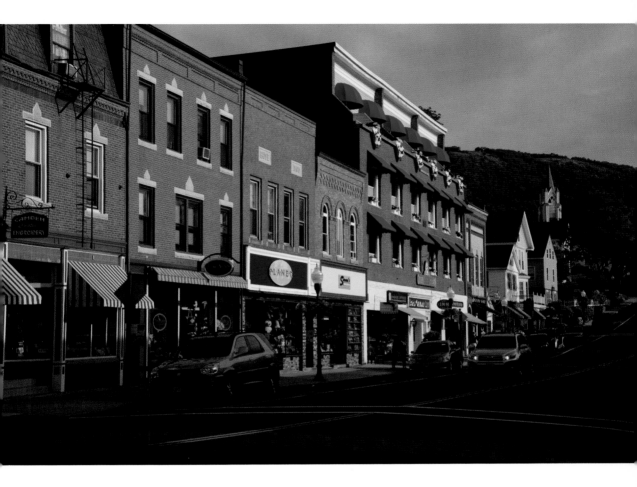

▲ Main Street, Camden

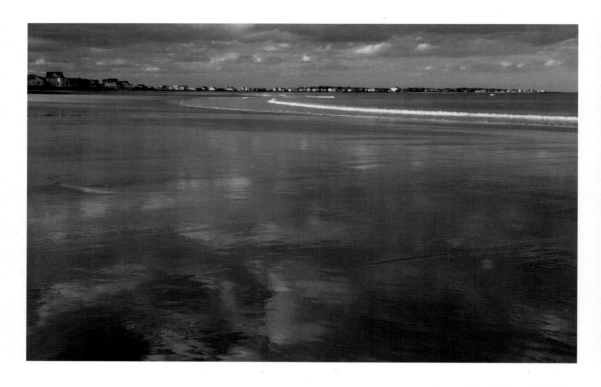

▲ Long Sands Beach, York

▶ Lobster boats in fog,
Boothbay Harbor

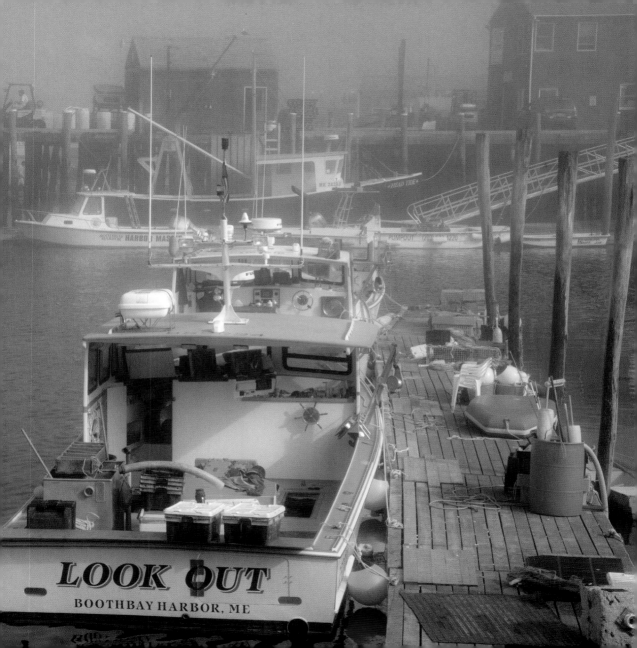

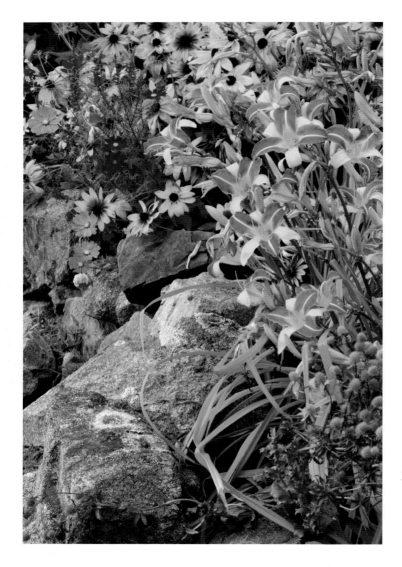

Maine's summer palette

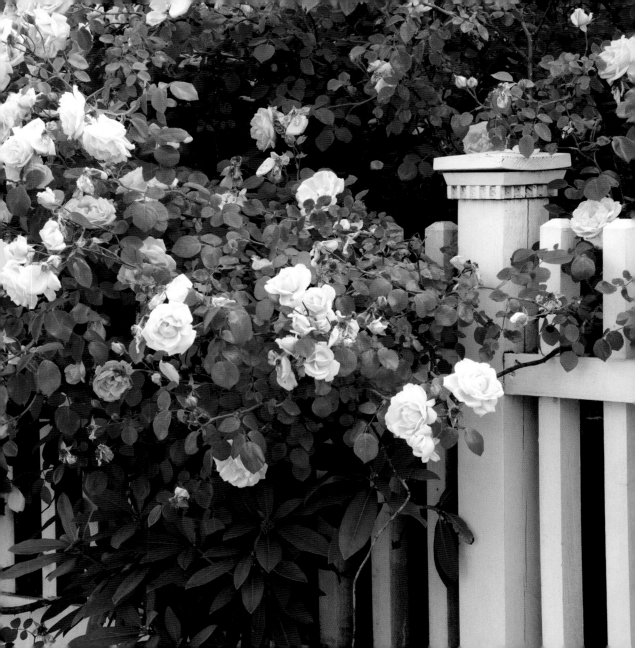

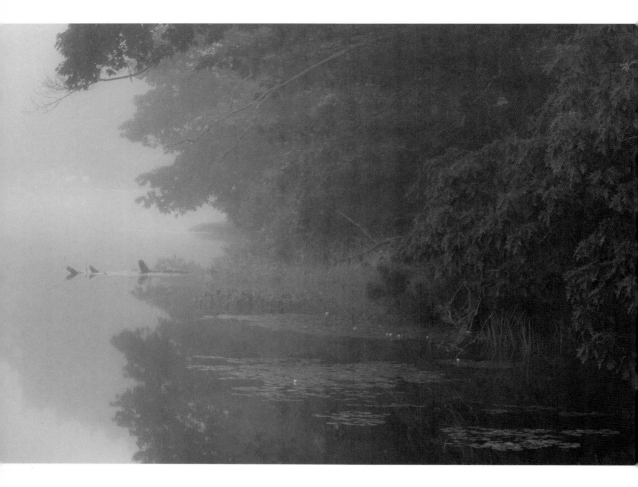

▲ Along the shoreline,
 Southport

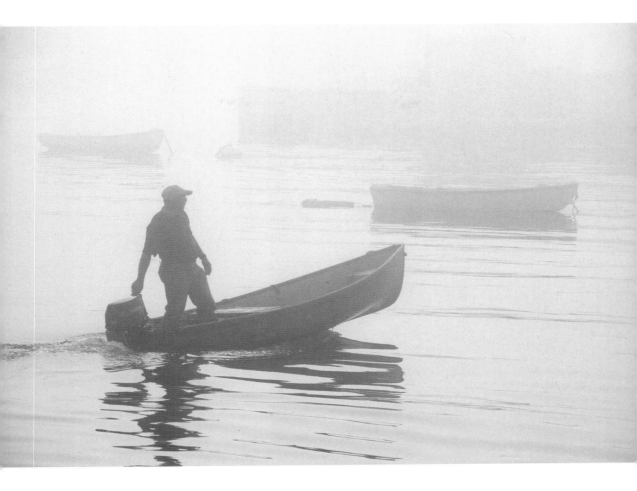

▲ Skiff, Owls Head Harbor

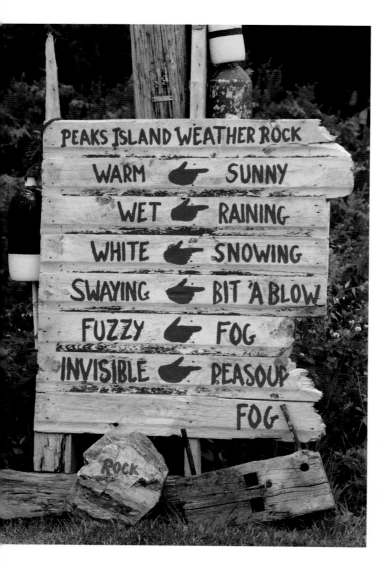

◀ A colorful signpost on Peaks Island

▶ Ice-cream stand, Tenants Harbor

▶ ▶ Navigating Acadia's carriage roads

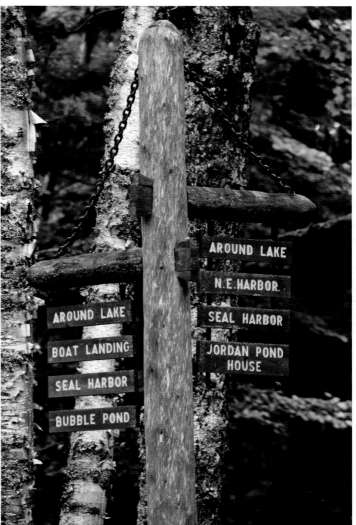

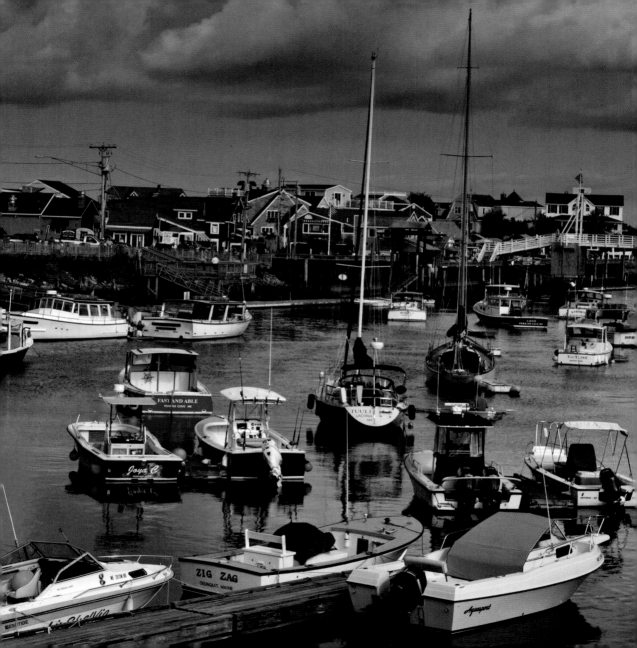

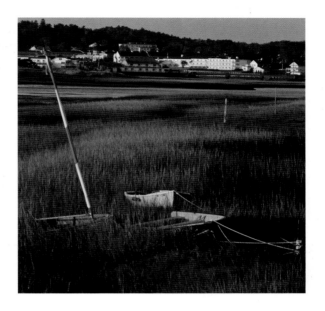

▲ Ogunquit salt marsh

◀ Perkins Cove, Ogunquit

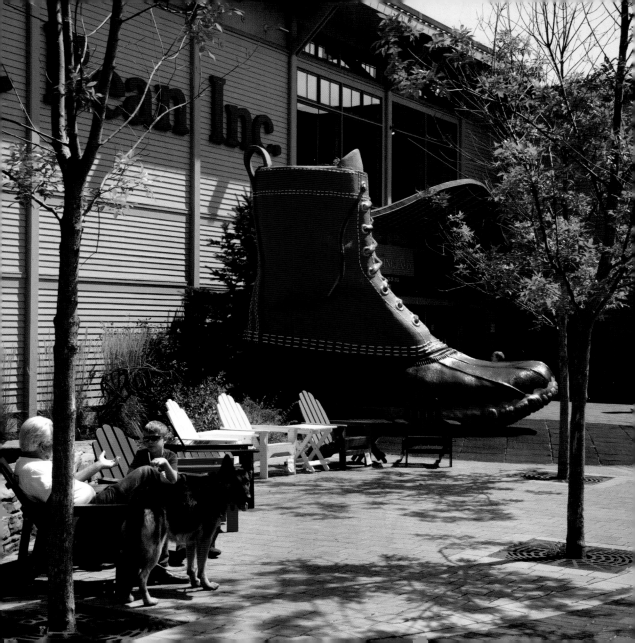

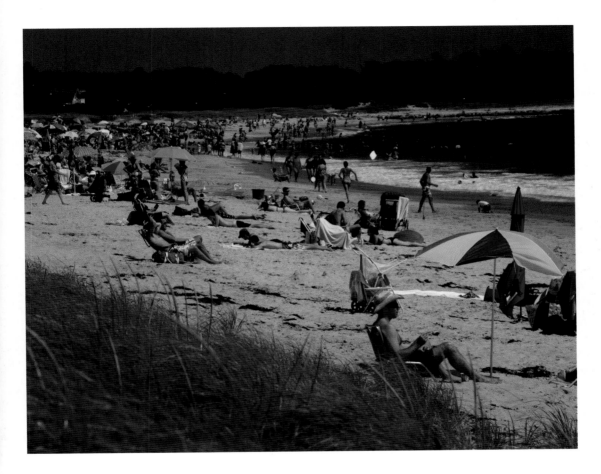

▲ Point Beach summer

◀ L.L. Bean's famous boot

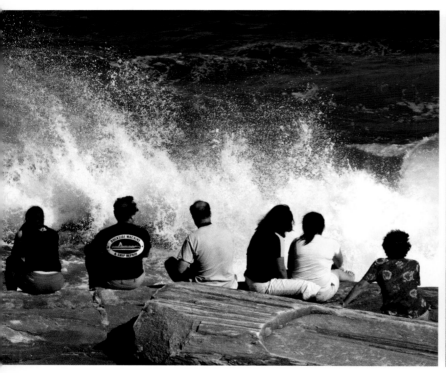

▲ Watching the
 waves crash

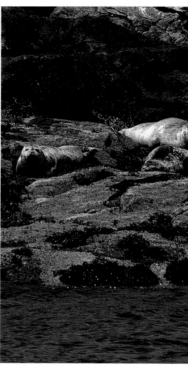

▲ Harbor seals

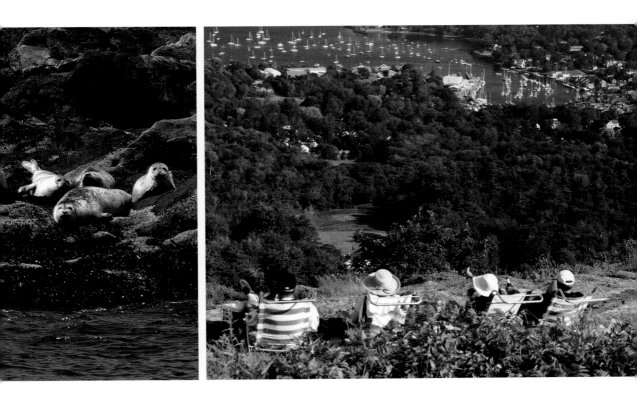

▲ View of Camden
from Mt. Battie

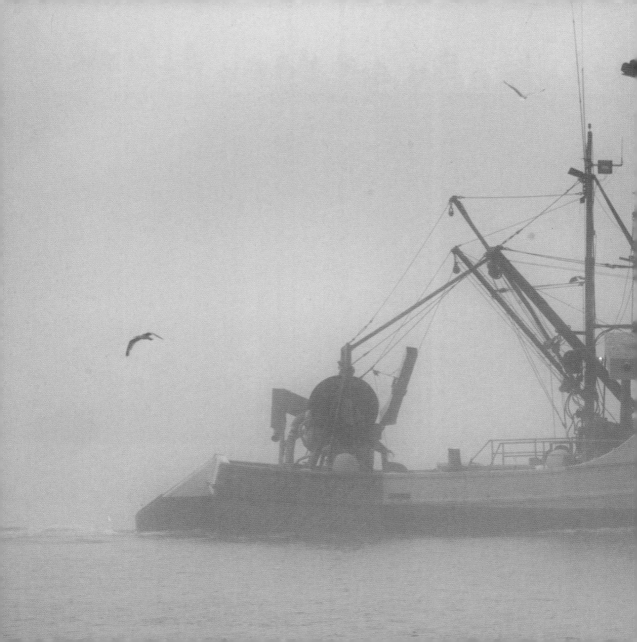

Fishing boat

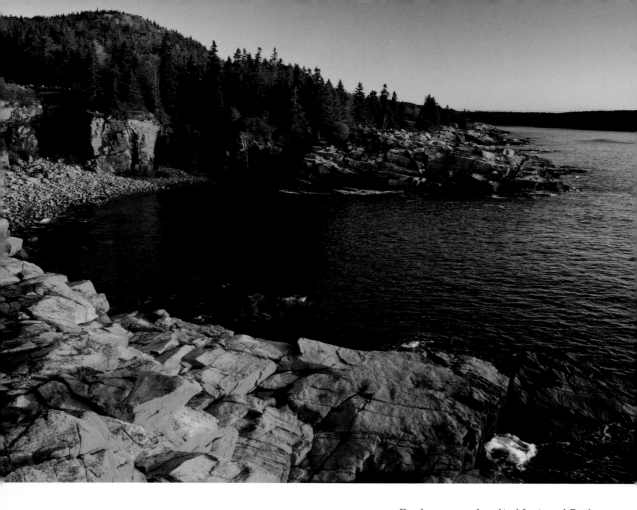

▲ Rocky coast, Acadia National Park

▶ Carriage path, Acadia National Park

MAINE COAST MEMORIES

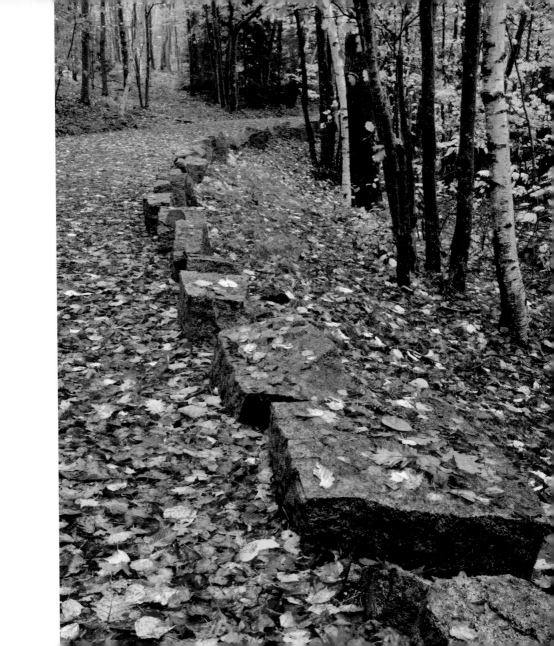

▲ Red maples

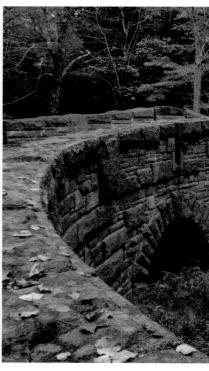

▲ Stanley Brook Bridge,
Acadia National Park

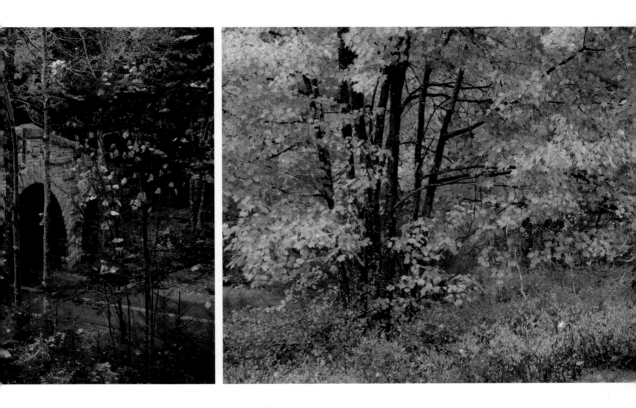

▲ Fall color

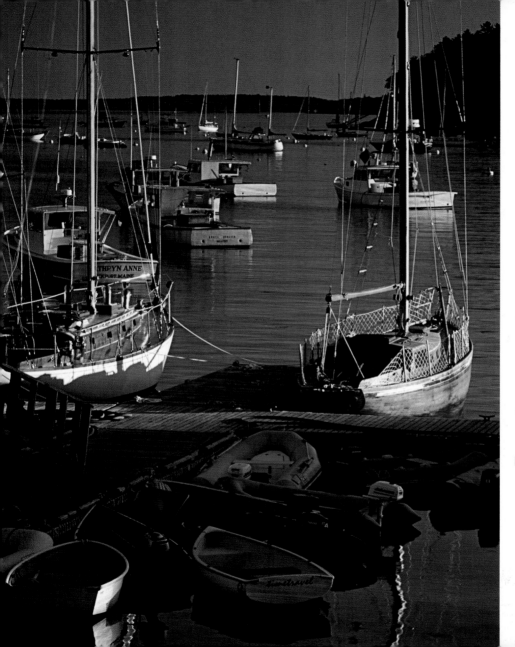

◀ Rockport
Harbor

▶ Boulder
Beach and
Otter Cliffs,
Acadia
National
Park

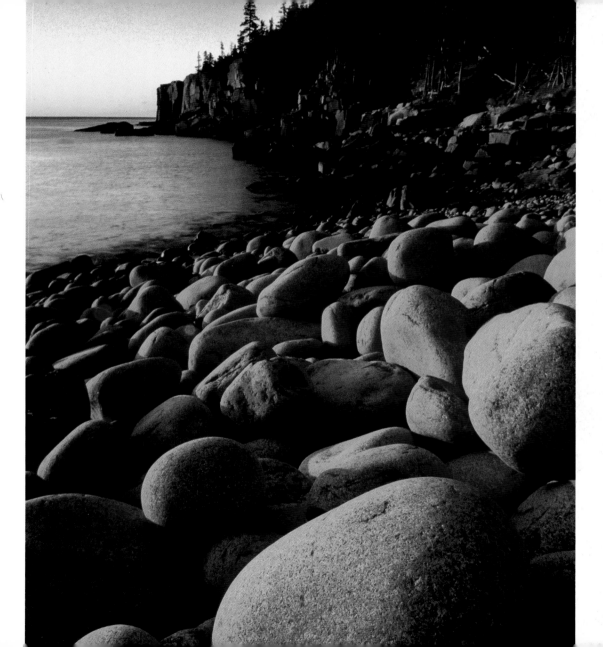

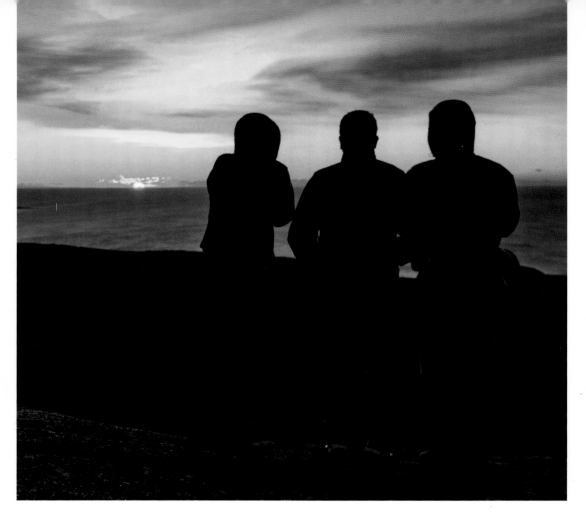

▲ Sunrise atop Cadillac Mountain,
Acadia National Park